ARTS AND CRAFTS

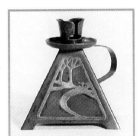

TEXT BY
JOANNA WISSINGER
CONSULTING EDITOR
RAYMOND GROLL

PHOTOGRAPHS BY
MARK SEELEN

METALWORK AND SILVER

THE DETAILS SERIES

CHRONICLE BOOKS
SAN FRANCISCO

A Packaged Goods Book

METALWORK AND SILVER
was conceived and produced by
Packaged Goods Incorporated
9 Murray Street
New York, NY 10007
A Quarto Company

Library of Congress Cataloging-in-Publication Data
Wissinger, Joanna.
 Metalwork and silver / text by Joanna Wissinger; photographs by Mark Seelen.
 p. cm.–(Arts and crafts)
 Includes bibliographical references and index
 ISBN 0-8118-0790-8
 1. Art metal-work–United States–History–20th century–Catalogs.
 2. Arts and crafts movement–United States–Catalogs.
 I. Title.
 II. Series: Wissinger, Joanna. Arts and crafts
 NK6412.W57 1994
 739' .0973'0904–dc20

 93-47527
 CIP

Design by Janine Weitenauer
Photo scouting by Margaux King

Distributed in Canada by
Raincoast Books
112 East Third Avenue
Vancouver, B.C. V5T IC8

10 9 8 7 6 5 4 3 2 1

Chronicle Books
275 Fifth Street
San Francisco, California 94103

Color Separations by Eray Scan Pte Ltd.
Printed and bound in Hong Kong by Sing Cheong Printing Co. Ltd.

Acknowledgments

As the author, I would like to thank

Raymond Groll,
our consulting editor, who gave of his time
and expertise without stint, and the following collectors
and dealers, without whose enthusiastic
and generous participation this book would not exist:

Rosalie Berberian and Aram Berberian
of ARK Antiques

Catherine Kurland, Lori Zabar, and Shawn Brennan
of Kurland•Zabar Gallery

Stephen Gray

David and Sandra Surgan

Thanks also to editor,
Mary Forsell

And to our photo scout,
Margaux King

Helen Groll, for her patience

And as always, my husband,
Paul Mann

Text References:
Page 9: From *The Stones of Venice*, "The Nature of Gothic" by John Ruskin, 1892; Page 10: From *The Beauty of Life* by William Morris, 1880; Pages 10 & 16: From *American Arts & Crafts: Virtue in Design* by Leslie Greene Bowman, Los Angeles/Boston: Los Angeles County Museum of Art/Bulfinch Press/Little, Brown, 1990, page 33; Page 11: From *The Craftsman*, No. 1, 1901, and *The Craftsman's Story*, 1905, by Gustav Stickley; Page 11: From *The Philistine*, No. 34, March, 1912 by Elbert Hubbard; Page 11: From *The Art that is Life: The Arts and Crafts Movement in America, 1875-1920* by Wendy Kaplan, ed., Boston: Museum of Fine Arts, 1987; Page 11: From *Country Time & Tide*, No. 4, September, 1903, by Edward Pearson Pressey; Page 15: From *Liberty Style* by Levy Mervyn, New York: Rizzoli, 1986; Page 18: From *California Design*, 1910 by Timothy J. Andersen, Eudorah M. Moore, and Roberts W. Winter, eds., Salt Lake City: Peregrine Smith Books, 1974.

CONTENTS

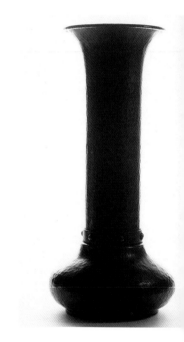

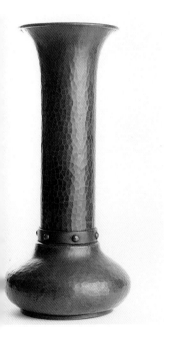

A SMART SILHOUETTE:
HAMMERED COPPER
VARIATION ON THE
AMERICAN BEAUTY
SHAPE FROM
THE ROYCROFT
COPPER SHOP.

COLLECTORS FIND THE FORMS AND MATE-
rials of Arts and Crafts objects attractive, yet
they are equally intrigued by the philosophy

INTRODUCTION

behind their design. The Arts and Crafts
Movement originated in England in the mid-nine-
teenth century as an idealistic protest against
industrialism, an attempt to return dignity to
labor and provide meaningful employment for
skilled craftsmen.

Believing that industrialization degraded
the life of the working class, Arts and Crafts
practitioners chose the decorative arts, which
are intertwined with the daily lives of all, as
the subject of their reform. They hoped to use
design and handicraft to create works of art

with a social as well as an aesthetic message. Two of the most important figures in the movement were John Ruskin and William Morris.

Ruskin was the first professor of art history at Oxford University, as well as the most influential art critic of his day. He was strongly opposed to industrialization and all use of the machine in manufacturing. Believing that assembly lines turned craftsmen into anonymous laborers, he asserted that a return to handwork would restore both individuality and quality. He proclaimed these tenets in many widely read books, including *The Seven Lamps of Architecture* (1849) and *The Stones of Venice* (1851, 1853). Ruskin's writings rang with passion; he penned many fervent passages, filled with memorable phrases,

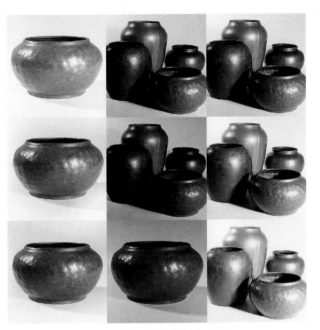

**ALL THE COLORS OF THE SUNSET:
RED WARTY WARE FROM DIRK VAN ERP**

on the plight of the working man: "Men were not intended to work with the accuracy of tools, to be precise and perfect in all their actions. If you will have precision out of them you must unhumanize them. We want one man always to be thinking, and another to be always working, and we call one a gentleman and the other an operative; whereas the workman ought often to be thinking and the thinker often to be working, and both

should be gentlemen, in the best sense. . . . It would be well if all of us were good handicraftsmen in some kind, and the dishonor of manual labor done away with altogether. . . . It is not that men are ill fed, but that they have no pleasure in the work by which they make their bread and therefore look to wealth as the only means of pleasure."

It is easy to understand how Ruskin's lucid plea for a more humane manufacturing process had the power to move an entire generation of young designers and artisans. William Morris was one of those in whom the reforming spark took fire.

Morris was not only a writer and lecturer but a talented designer and craftsman in his own right. Encountering Ruskin's ideas at Oxford in the early 1850s, where he had originally gone to study for the ministry, he decided instead to commit his life to reform through the decorative arts. In 1861, Morris established his own firm, Morris, Marshall, Faulkner & Co. (reorganized in 1875, it was renamed Morris & Co.) with the goal of making things that were both useful and beautiful. The firm produced furniture, stained glass, wall paintings, painted tiles, embroidery, table glass,

metalwork, and, after 1875, hand-printed textiles and wallpapers as well as tapestry and carpets, many designed by Morris himself. The wallpaper and fabric designs, derived from the natural geometry of plants and animals, were hand-printed from wooden blocks.

Morris's writings were known to American followers of the Arts and Crafts Movement; his products were also widely available in department stores in both Europe and America. His tremendous influence stemmed from his frequent writing and lecturing, championing the honest use of materials, simplicity of form, and a belief in organic beauty. Like Ruskin, he wrote stirring passages on the need to introduce art into every-day life, and by doing so, improve the lives of all; his best-known saying is "If you want a golden rule that will fit everybody this is it: have nothing in your houses that you do not know to be useful or believe to be beautiful." These principles appealed to many craftsman and artists around the world, particularly in the United States, who agreed with his declaration: "What business have we with art at all, unless we can share it?"

Examples of fine English Arts and Crafts metalwork abound, particularly in silver and pewter. Illustrated in these pages is the work of C.R. Ashbee of the Guild of Handicraft, as well as a silver bowl made by Edward Spencer of the Artificers' Guild. Ashbee, too, was a follower of Ruskin and Morris, a reformer and craftsman whose books and pamphlets proclaimed the tenets of the Arts and Crafts Movement and championed the establishment of craft work-shops: "I do not say that the artisan has any appreciation of the true sense of Beauty, far from it, but I affirm that if we could look for its development anywhere, it is with the portion of the community who are seeking to break its commercial traditions and to construct a newer social order, in which, let us hope, the sense of Beauty may find more room for growth." The ideal of Arts and Crafts design was adapted for mass production by such firms as Liberty of London, which sold silver, pewter, and copper pieces, many designed by Archibald Knox and produced by W. H. Haseler of Birmingham. While English pieces are on the whole more elaborate than those made in America, there is a clear continuity of motif and material. Not only the forms but the philosophy made the journey across the Atlantic.

In the United States, the Arts and Crafts movement flourished from about 1890 to 1915. Elbert Hubbard and Gustav Stickley were two key figures. Both had direct experience, albeit not extensive, with Morris's work and were influenced by his ideas, each having visited England at different times in the 1890s. Hubbard claimed to have met Morris briefly while visiting his Kelmscott Press in 1894, returning to found the successful Roycroft Community, a commercial craft guild based to some extent on Morris's teachings. Stickley visited England in 1898, where he was able to see the work of many English Arts and Crafts designers, inspiring him to introduce his line of Craftsman furniture

soon after. Completely immersing himself in the aesthetic, he went so far as to begin publishing an influential Arts and Crafts magazine, *The Craftsman*. He devoted the first two issues to discussions of Ruskin and Morris. As he stated in his introduction to the first number, he founded his furniture company in order "to promote and extend the principles established by Morris, in both the artistic and socialistic sense . . . to substitute the luxury of taste for the luxury of costliness; to teach that beauty does not imply elaboration or ornament; to employ only those forms and materials which make for simplicity, individuality and dignity of effect."

A few years later, in 1905, Stickley wrote in *The Craftman's Story*, a pamphlet which detailed the history of his enterprise, "Just as we should be truthful, real, and frank ourselves, and look for these same moral qualities in those whom we select for our friends, so should the things with which we surround ourselves in our homes be truthful, real, and frank. We are influenced by our surroundings more than we imagine."

Hubbard was a fascinating figure who constantly reinvented himself. A high school dropout at sixteen, Hubbard was an advertising pioneer who established the successful J. D. Larkin Company with John Larkin, his brother-in-law. From 1892 to 1893, he sold out his business interests and studied at Harvard as a special student. Too restless to be confined to a classroom, he left in 1894 for a walking tour of England. There he was deeply impressed by the philosophy and business practice of Morris and returned home fired up to write a series of biographical sketches called *The Little Journeys*. Unable to find a publisher for these inspirational volumes, he decided to publish them himself. Such was the genesis of the Roycroft Press, phase one of the Roycroft Community.

Hubbard's own strength lay not in handicraft but in wordcraft. He was a master copywriter and without his vast influence in the nascent world of American advertising, the Arts and Crafts Movement might not have become as popular as widely and rapidly as it did. Not only did Hubbard write much of the copy for the Roycroft catalogs, which described the products available from the workshops (an example from the 1919 edition: "Beautiful objects should be owned by the people. They should be available as home embellishments and placed within the reach of all"), he also, in his many outside ventures, associated his clients with the virtues of the Arts and Crafts lifestyle. "'Art,' says William Morris, 'is not a thing but a way.' It stands for reciprocity, mutuality, beauty, order–Human Service," read one such advertisement he created for a hotel (quoted in *The Art that is Life*).

Made up of the efforts of many individual craftsmen, each striving to do his best work, the Arts and Crafts Movement, was, in the words of Edward Pearson Pressey, founder of New England's Clairvaux handicraft community, "a soul-reaction from under the feet of the corporations and the wheels of machines," an inspiring affirmation of the movement's belief in the power and beauty of art.

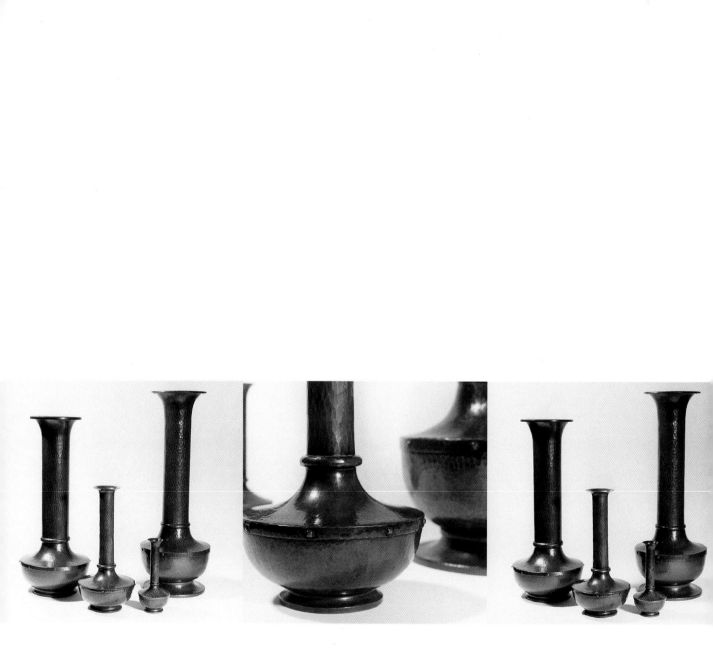

GROUPED HERE AS IF FOR A family portrait, Roycroft's circa-1912 American Beauty copper vases were originally available in four sizes: seven, twelve, nineteen, and twenty-two inches high. The nineteen-incher was depicted in a catalog holding American Beauty roses, hence the name. Each size had its own special use. The smallest was intended as a

AMERICAN BEAUTIES

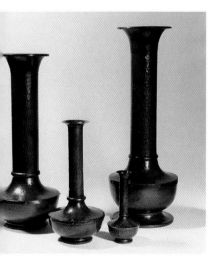

bud vase; the intermediate sizes, for holding larger arrangements; and the biggest, as a floor vase.

The Roycroft Copper Shop was the largest and perhaps best known of the many Arts and Crafts metalwork shops of the early twentieth century. At its height, from about 1915 to 1919, thirty-five workers were employed there, producing many different objects, which ranged widely in quality and rarity. Roycroft copper patinas were marvelously varied, from dark brown to brass and even silver finishes. Particularly unusual were objects of a deep blue bronze, and those with a greenish patina, as well as multicolored Italian Polychrome.

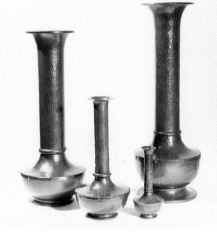

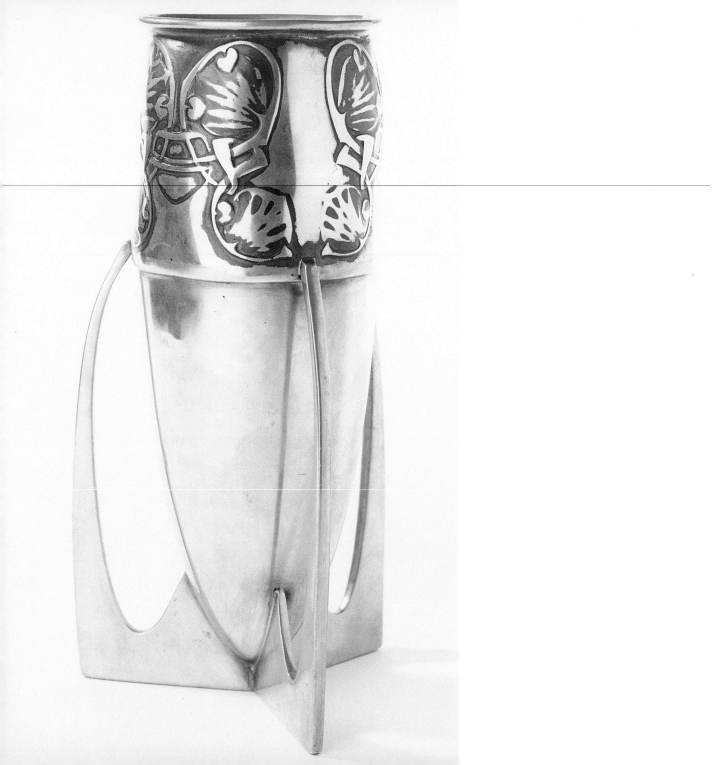

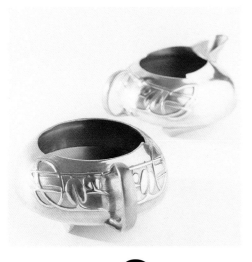

TUDRIC WAS LIBERTY'S LINE OF ARTS and Crafts pewter, the examples shown here date from circa 1903. The name, which sounds vaguely Welsh, is an invented word intended to give a Celtic accent to the designs. Indeed, they employ the interlacing and stylization of this ancient culture.

Appearing to hover weightlessly, the "rocket-ship" vase (opposite page) is a design by Archibald Knox, Liberty's chief metalwork designer. It exists in various versions, all with handles that rejoin the body to form the base. This shape, with its dynamic use of negative space and

Space age shapes

its "space age" shape, as Mervyn Levy put it in *The Liberty Style*, seems to provide a direct link between Arts and Crafts design and Modernism.

The cream jug and sugar bowl (above) were available as part of a five-piece coffee or tea set, also designed by Knox. Their stylized ornament, though it appears completely abstract, is based on the stems and seedpods of the honesty plant (also known to the pecuniarily minded as the money plant, to the psychologically versed as lunacy plant, and to gardeners by its genus name of *Lunaria*).

STICKLEY CIGAR BOX

"ONLY HANDWROUGHT METAL IN SIMPLE, rugged designs would do, and the only way to get this was to make it ourselves," wrote Gustav Stickley in a 1905 publication (quoted in *Virtue in Design* by Leslie Greene Bowman). Though Stickley originally commissioned his first pieces of metalwork simply to supply suitable hardware for his Craftsman oak furniture, his imagination soon took hold, with the result being such exquisite accessories as this cedar-lined cigar box, as well as this tray (circa 1908 to 1916).

The Stickley metalwork available from the Craftsman Workshops is characterized by a rough, planished surface, with the marks of the hammer deliberately left visible, rather than smoothed out, imparting a medieval, hand-crafted air. Similarly, the metal was treated to create a patina that implied years of use.

BORN IN HOLLAND IN 1860, DIRK VAN ERP had a direct connection to handicraft of the pre-industrial world—that William Morris, Gustav Stickley, and Elbert Hubbard tried so diligently to recreate. Unlike these entrepreneurs, however,

EARLY DIRK VAN ERP

van Erp was a true product of the vernacular tradition. Certainly, van Erp lacked formal training in design, but that cannot be considered a handicap. Wonderful in their simplicity, these brass vases, hammered from surplus military shell casings, are early examples (circa 1904 to 1908).

Son William van Erp testified to his father's ease and spontaneity when working: "(He) had it in his head and in his hands. There was no lost motion whatsoever when he started to make a piece. (Either) it came out a very nice piece, (or) it never got made at all." (quoted in *California Design, 1910*, Timothy S. Andersen, Eudorah M. Moore, and Robert Winter, editors).

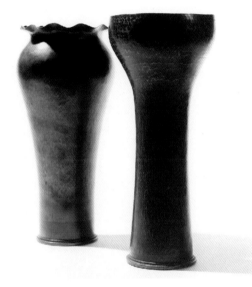

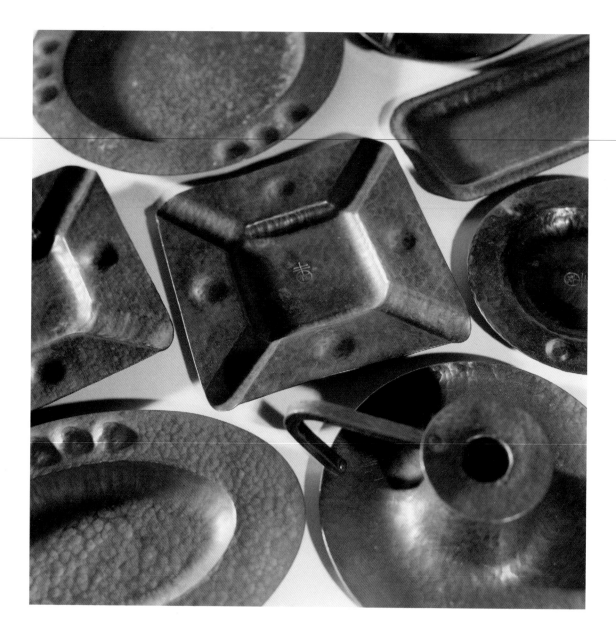

PUNCHED-OUT GEOMETRIC DECORATION,
simple shapes, and basic flat brown pati-
nas characterize these copper ashtrays,
candleholders, and trays, circa 1908 to 1910,

EARLY ROYCROFT

from Roycroft's earliest production period.
Before Karl Kipp—perhaps Roycroft's pre-
mier metal craftsman—joined the Copper
Shop and became head designer, Roycroft's
products were much cruder. However, these
rough shapes and dull finishes have a cer-
tain charm of their own and are particularly
appealing—if not irresistible—to Arts and
Crafts collectors.

HEINTZ ART METAL

IN 1912, OTTO HEINTZ PERFECTED HIS TECHNIQUE OF BONDING STERLING SILVER overlays onto bronze bodies to create a variety of pieces, which he sold under the trademark Heintz Art Metal. In all, the materials are the same, despite the different patinas. The bronze vases shown here have green and brown patinas with sterling silver overlay and date from circa 1912 to 1928.

A brochure accompanying each piece of Heintz Art Metal proclaimed, "The article which this accompanies is a genuine Heintz piece. The creators of this line have taken bronze—the metal which even to ancients expressed strength, stability, and solid worth—because the history of bronze would tend to place it in that class of metals which might be called Metals of Romance—to which also belongs silver. . . ."

"The silver, when designed, is sawed by hand from a solid sheet, and the pattern then molded to the bronze base and brazed or soldered thereon, which so fuses the two metals that it is almost impossible by any means to again separate them." Interestingly enough, Heintz' "secret method" was actually a solderless process, although the undated sales literature quoted above seems to state otherwise. Perhaps this way was an attempt to mislead competitors.

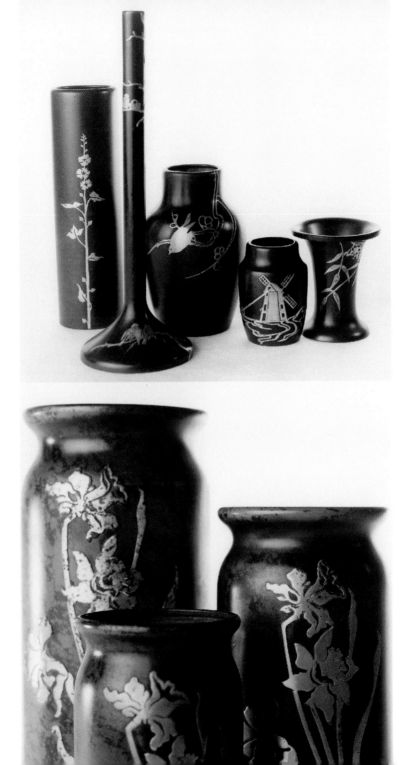

FLORENTINE LEATHERWORK MAY WELL HAVE
been the inspiration for the bands of tooled decora-
tion on Roycroft's line of Italian Polychrome. Though
similar to other Roycroft designs, these copper vases

ITALIAN POLYCHROME

and bowls, dating from circa 1912, are distinguished
by an unusual green enamel over the tooled areas,
combined with a brown patina. The extraordinary effect
of multiple hues inspired the second half of the name,
polychrome, which means "many colored."

This line, which is very rare, was probably
designed by Walter Jennings, chief assistant to Karl
Kipp. There is speculation that the two small dots
within the orb of the Roycroft symbol are Jennings's
personal mark. The petal-like, broadly ribbed sides of
the bowls and vases are subtly organic and are remi-
niscent of the forms of Arts and Crafts pottery.

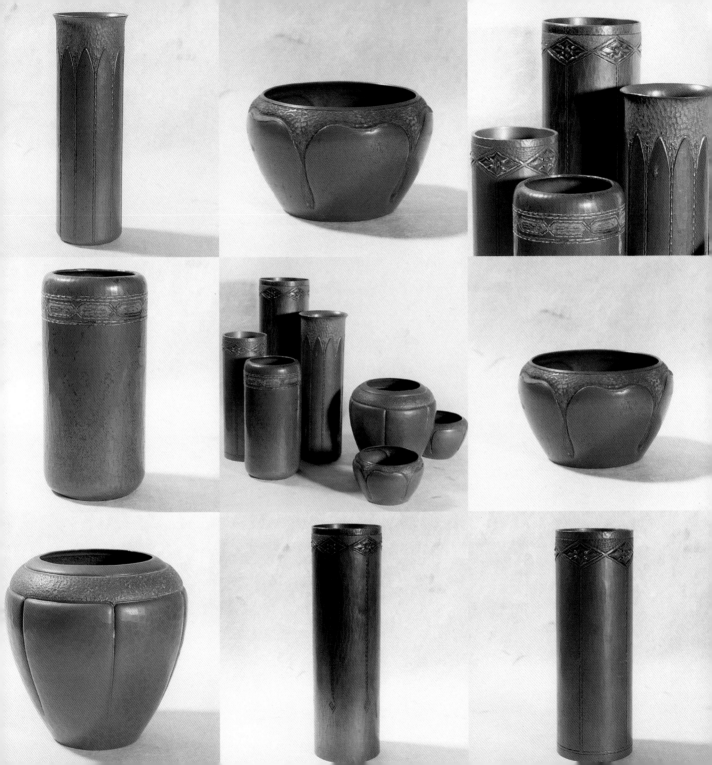

BEAUTIFUL BUT USEFUL

AS VARIED AS THE PERSONALITIES OF their makers, boxes were obviously a favorite form of both English and American metalworkers, as reflected by this diverse selection of creative expression.

Oftentimes, boxes reflect their maker's surroundings, as with the copper cigarette box with horn ornament (A), created by American Albert Berry around 1925. Originally based in Boston, Berry moved to the Pacific Northwest sometime around 1918, and he may have created this box with materials collected during a stint in Alaska, before moving to Seattle. Had

Berry remained in Boston, his work might have more closely resembled the box (B) by the Handicraft Society of Boston. Dating from circa 1910 to 1916, the copper box has a beautifully enameled lid and actually resembles the circa-1905 work of Englishman F. C. Varley (F). A member of the Guild of Handicraft, Varley was admired for his moody landscapes.

Enameling was also a favorite form of decoration at the Art Crafts Shop of Buffalo, New York. Most examples designed by Otto Heintz have peaked lids, are enameled on all four sides as well as the top, and have riveted corners, giving them an earthy, hand-crafted feeling. The copper examples shown here (C and H) date from circa 1903 and 1905, the height of Art Crafts Shop production.

A B C D

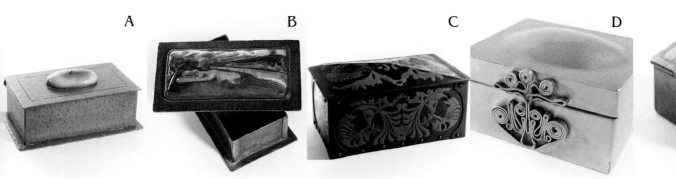

American Harry St. John Dixon, brother of painter Maynard Dixon, found other means of ornamenting boxes. The catch of this twenties-era pewter cigarette box (D), while seemingly complicated, is really very simple. Its straight tongue slides into the complex curvilinear ornament and is concealed by its intricate design. Similar boxes designed and executed by Dixon, most frequently in copper, are sometimes known as "puzzle boxes."

Collectors also seek out the later work of Buffalo artisan Otto Heintz, produced under the trademark of Heintz Art Metal Shop (the actual mark is the letters HAMS set within a diamond). A lovely example is this circa-1912 box (I) depicting a stylized tree, a typical Arts and Crafts motif, in sterling silver overlaid on bronze.

Rivaling the richness of these American designs, a circa-1900 box by Englishman John Pearson (G) depicts a fabulous setting. Pearson was one of the four original members of the Guild of Handicraft and its first metalwork instructor. His work often illustrates fanciful creatures such as dragons, and was possibly inspired by Medieval objects.

Though some Arts and Crafts collectors prize decorated boxes, others prefer the relative simplicity of the designs from Craftsman Workshops.

Possibly intended to hold postage stamps, this circa-1910 copper example (E), with its light-catching hand-hammered surface, exemplifies the much-desired quality of beauty united with simplicity.

E F G H I

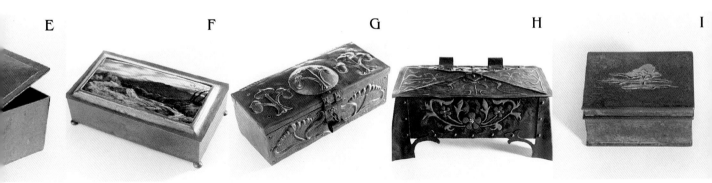

IN 1908, AT AGE EIGHTEEN, Harry St. John Dixon decided to become a metal artist and apprenticed himself to Dirk van Erp. He also trained with other metalworkers in the San Fran-

SIMPLY HARRY ST. JOHN DIXON

cisco area. Although much of his individual studio work was created after the heyday of Arts and Crafts design, Dixon worked in an extension of the style. As a student of van Erp, he was certainly nurtured in the tradition. The simplicity of form exhibited by these copper vessels, circa 1915 to 1925, arises from their having been hammered out of a single piece of metal.

28
.

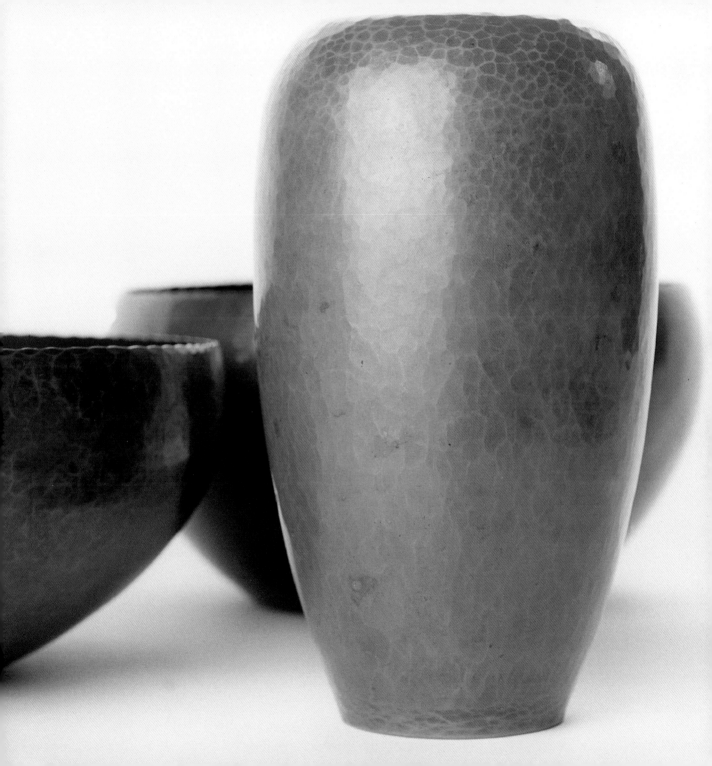

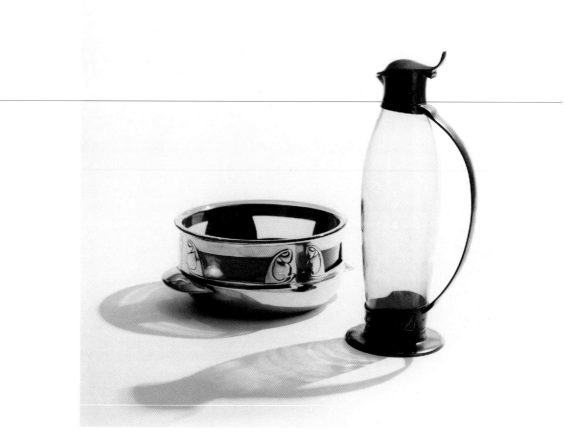

BORN ON THE ISLE OF MAN IN THE IRISH SEA, Archibald Knox had a thorough knowledge of traditional Celtic ornament, which involves complex interlacing and geometric patterning over the surface of an object. The Celts were the original inhabitants of Western

CELTIC PEWTER

Europe. They invaded the British Isles circa 250 B.C. and by the first century had established a high standard of metalwork.

As chief designer of silver and pewter for Liberty, Knox employed simplified versions of Celtic ornament—such as this pewter claret jug with green glass body and pewter stand for a glass fruit bowl, circa 1903—consistent with the Arts and Crafts practice of looking to historic, indigenous sources for inspiration.

Knox has on occasion been described as a designer equal in merit to such better-known figures as Scots architect Charles Rennie Mackintosh. Through his individual innovations and adaptation of tradition, Knox had a singular influence on the development of what has come to be known as "Liberty style."

BISCUIT BOXES

A BISCUIT BOX IS THE English version of a cookie jar and has long been an indispensable item for holding these tea-time treats. These circa-1903 pewter biscuit boxes by Liberty—decorated with horizontal bands of square-shaped leaves and flowers and, on one example, enamel cabochons—display the simple shapes typical of Archibald Knox's designs.

The practical nature of these pieces reflects Knox's connection with Christopher Dresser, the great Victorian industrial designer, who was one of his mentors. Dresser was well known for his belief in functionalism and simplicity of design.

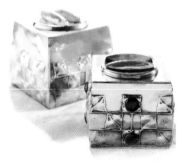

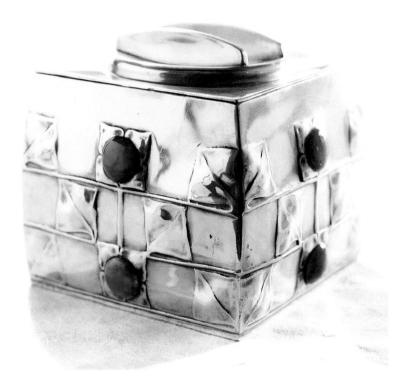

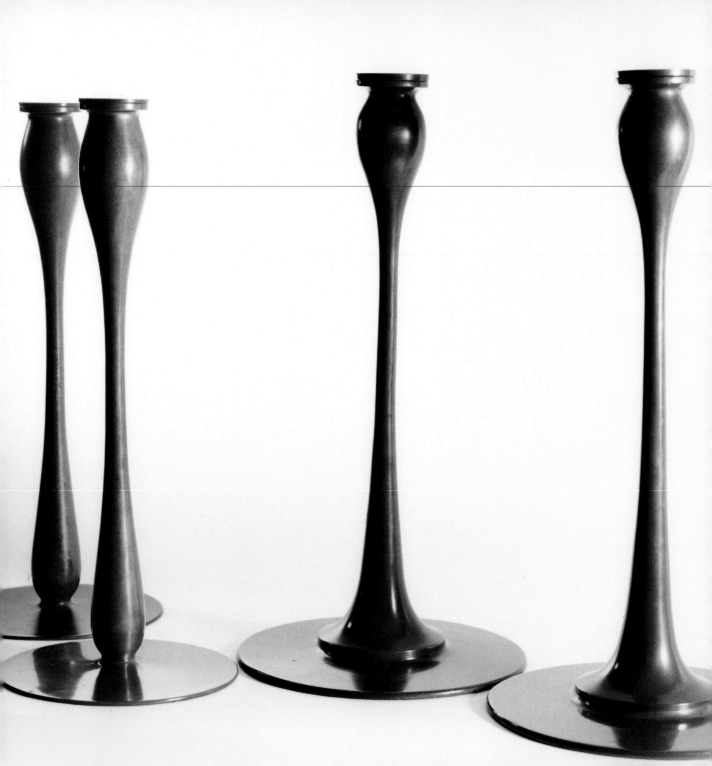

TALL AND SLEEK, ROBERT JARVIE'S BRONZE candlesticks are both abstract and organic. He designed a number of different versions of this basic style and named them after letters of the Greek alphabet, from Alpha to Lambda. Here, the slender forms of Theta and Iota, circa 1904 to 1910, resemble flower buds in form but have an undeniably strong, elegant presence.

ROBERT JARVIE: THETA AND IOTA

Jarvie—who advertised himself as the "Candlestick Maker"—was one of the most successful Arts and Crafts metalworkers. As a clerk in the Chicago city government, he began teaching himself metalwork. The enterprising artisan was soon exhibiting his lamps and candlesticks, first in the Chicago Arts & Crafts Society's third annual exhibit in December 1900 and again in 1902 in a show held at the Art Institute of Chicago. Inspired by his successes, Jarvie went into business for himself, advertising candles and lanterns for sale in *House Beautiful* magazine, at that time based in Chicago. By 1903, his designs were so popular that others were reproducing them, prompting him to announce that all his candlesticks would henceforth bear his signature. He soon left his job with the city and established the Jarvie Shop, creating the elegant wares that collectors so covet today.

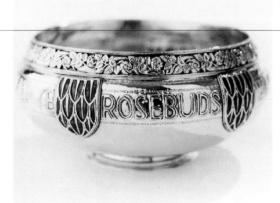

ENGLISH SILVER

ADORNED WITH A FRIEZE OF ROSES and thorns, this circa-1912 planished-silver bowl by the Artificers' Guild (above) is appropriately inscribed with verse from Robert Herrick's "Gather Ye Rosebuds While Ye May." It is rather elaborate in comparison to work of other English makers, as well as American examples.

The guild was founded in 1901 by Nelson Dawson and his assistant, Edward Spencer, and first located in London's fashionable Mayfair district. It was one of few commercially successful crafts guilds, continuing in business until it closed down in the early 1940s.

By contrast, C. R. Ashbee's Guild of Handicraft, founded in 1888, had its philosophical origins in London's decidedly *un*fashionable East End. The guild was both workshop and school, where self-taught metalworkers followed Ashbee's designs to create metalware in copper, brass, and silver. Ashbee, himself a Cambridge graduate, was self-taught in metalworking techniques. An example of one of Ashbee's creations is this circa-1904 cloak clasp (opposite page), one half of which can also be worn as a pin or pendant. It is adorned with a central enamel disk set within a filigree of leaves and green turquoise.

In 1902, the guild moved its premises from London to rural Chipping Camden, taking over an old silk mill. But soon the whole idea of handicraft–or at least its appearance–became so popular that other manufacturers with less lofty ideals had gotten into the game. In 1908, the guild went into voluntary liquidation.

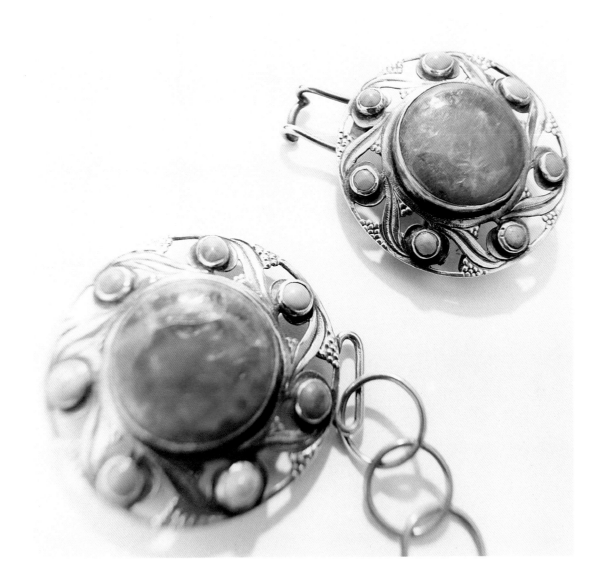

THOSE WHO BELIEVED STRONGLY
in the tenets of the Arts and Crafts
Movement were certain to own a lot
of books. After all, the Roycroft
Community started as a printing
press and continued to design and

BOOKENDS

produce a variety of publications
through the years. Gustav Stickley
published many volumes of *The
Craftsman*, the premier Arts and
Crafts journal, and many designers
and makers of decorative objects
produced catalogs and brochures. As
a result, there was plenty of reading
material available. Represented here
by copper examples from Dirk van
Erp, Roycroft, Karl Kipp, and Albert
Berry, these bookends kept libraries
tidy and orderly. As a catalog from
Karl Kipp's Tookay Shop (pronounced
"2K") put it, "These adjustable book-
ends of hand-modeled copper will be
appreciated by everyone of good
taste who has a den, library, living
room or office."

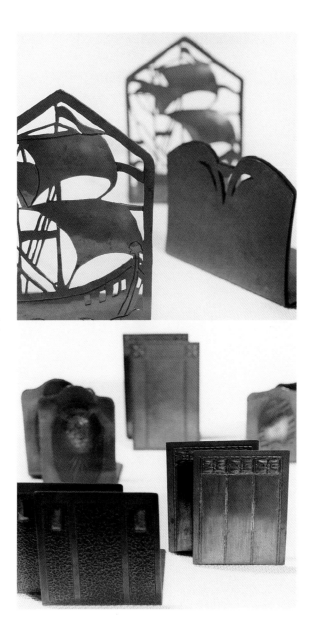

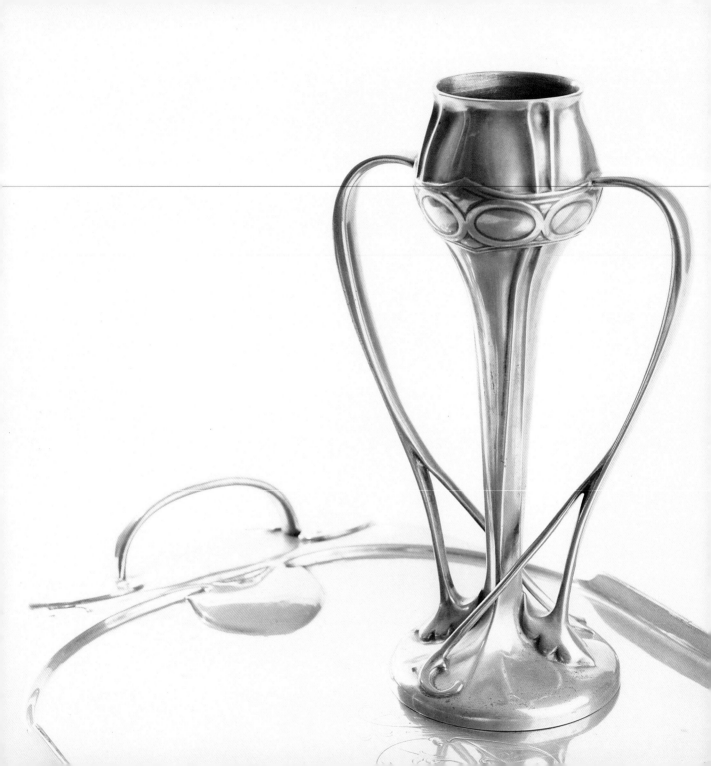

EARLY LIBERTY

RIVETED HANDLES AND SIM-
plicity of design on this circa-
1901 pewter tray suggest the
early phase of Archibald Knox's
pewter designs for Liberty, sold
under the name known as Li-
berty Tudric. As a Liberty cata-
log from the turn of the century
noted, "Simplicity is the keynote
of its design." The pewter bud
vase, which dates from a few
years later, has a floriform base
from which tendrils seem to
sprout. Its flowing lines reflect
the influence of Continental Art
Nouveau. While Knox's oeuvre is
often praised as a precursor of
Modernism, these two pieces
demonstrate his links with other
tendencies in early twentieth-
century design.

FIN DE SIÈCLE VIENNESE DESIGN most certainly influenced Karl Kipp when he designed (though he probably didn't make) this copper tobacco jar and pair of candlesticks for Roycroft—sometime around 1910 to 1912—ornamenting them with a number of applied squares of German silver.

SQUARES OF GERMAN SILVER

The Viennese influence can be traced as follows. Dard Hunter, an influential figure at Roycroft, journeyed from East Aurora, New York, to Vienna during the period from 1908 to 1909. His trip may have been sponsored by Elbert Hubbard himself. Upon Hunter's return, he collaborated with Kipp, head of the Copper Shop, on a number of lamp designs. Hunter obviously influenced Kipp, a former banker who had joined fortunes with Roycroft in 1908. Although Kipp started out as a book binder, he became head of the Copper Shop and created some highly distinctive designs.

In 1911, Kipp and his assistant Walter Jennings, left to form the Tookay Shop, also in East Aurora. In 1915, after the death of Hubbard on the *Lusitania,* Kipp and Jennings came back to resume to work at Roycroft at the invitation of Hubbard's son, where Kipp remained until his retirement in the early 1930s.

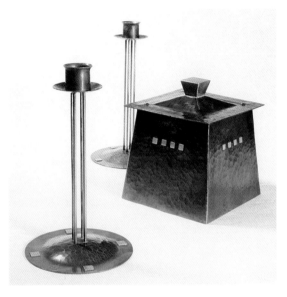

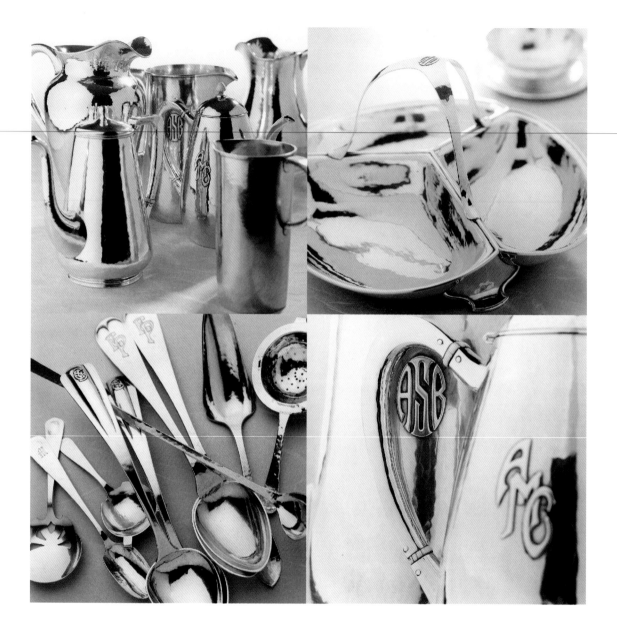

IT WAS IN CHICAGO—A CITY FREE OF THE restraints of conventionalism, eager to compete with the staid East—that silver with an Arts and Crafts influence reached its height. The World's Fair of 1893 established Chicago as symbol of urban life (by 1890, Chicago was the second largest city in the United States). While the preference back East tended to be traditional (although Boston produced a number of notable silver artisans) in Chicago, silversmiths from a variety of backgrounds were able to support themselves by designing and making exciting and innovative objects. The metalworkers of the Chicago School shared a belief in simplicity of form and the dignity of fine craftsmanship as the sole adornment of their ware.

One of Chicago's most influential silversmiths was Clara Barck (later Clara Welles). A graduate of the School of the Chicago Art Institute, she opened the Kalo Shop in 1900, although it was not until after her 1905 marriage to an amateur metal artist named George Welles that she became interested in jewelrymaking and metalware. The couple established a workshop in their home, which they called the Kalo Art-Craft Community, and opened a shop on fashionable Michigan Avenue. The Kalo Shop became best known for its silver objects, which have a distinctive, soft line (as with the circa-1910 child's cereal bowl in the upper right photo and the serving spoons in the lower left photo). Aside from applied monograms and a rounded border applied to strengthen the rim (evident in top left and bottom right photos), Kalo wares were utterly simple.

Fallick Novick, a Russian immigrant who opened a shop in 1909, was strongly influenced by the Kalo Shop. A pair of Novick's circa-1925 serving spoons (lower left photo) as well as a circa 1918 water pitcher (upper left) admirably illustrate the sophisticated simplicity of his style.

Julius Randahl worked at the Kalo Art-Craft Community from 1907 to 1910, where he was trained by Clara Barck Welles. He opened a shop of his own in 1911. A circa-1925 brandy spoon

CHICAGO SILVER

and circa-1917 tea strainer (both lower left), as well as a coffeepot dating from about 1916 (upper left) testify to his artistry.

Another important figure was Jack M. H. Lebolt, who, perhaps inspired by the existence of the Marshall Field Crafts Shop, established a metal workshop in 1912 to supply handwrought silver for his retail jewelry store. The workshop developed lines of heavy hammered silver tea and coffee sets, along with flatware and jewelry (examples in lower left photo).

Though Robert Jarvie was well known for his bronze candlesticks, by about 1910 he had shifted his focus to silver trophies and presentation ware. At the same time, he had become a member of the Cliff Dwellers, a group of artists, writers, musicians, and craftsmen with a meeting room located in Chicago's cultural hub. There he came under the influences of Prairie School architect George Grant Elmslie, which resulted in a new style for Jarvie's silverware—more geometric, with abstract repoussé ornament. Jarvie's circa-1913 milk pitcher (upper left) beautifully realizes his vision.

Buffalo bungalows

GROUPED LIKE A BUN-
galow colony, these various
boxes for holding cigars,
stamps, and cigarettes, along
with an inkwell, illustrate
the variety of wares produced
by the Art Crafts Shop of
Buffalo during the period
from approximately 1900
to 1908. The copper and brass
objects are distinguished
by their characteristically
dramatic and exuberant
enamel decoration, which
depict not only flowers
and leaves but leaping
fish—as on the inkwell—and
twining serpents. The very
dark patinas on the base

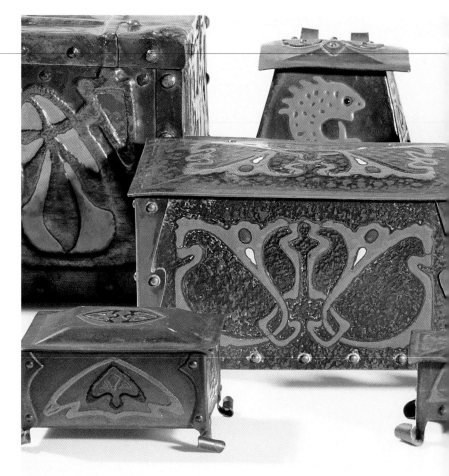

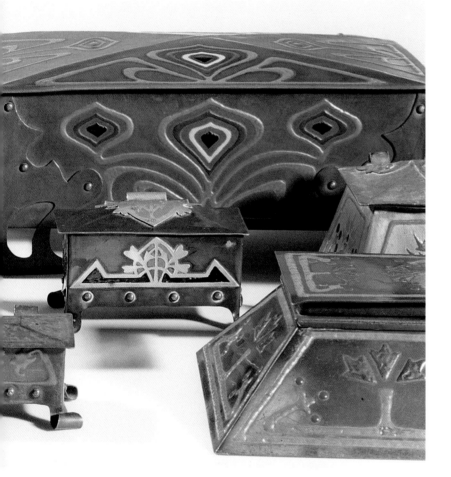

metals serve to show off the enamel work to great advantage.

Much of the production of the Art Crafts Shop was designed by Bernard Carpenter, who had come to Buffalo in 1892 to teach in the design department of the Albright (now Albright-Knox) Art Gallery's School of Fine Arts. Trained in Boston and Paris, Carpenter appears to have begun collaborating in 1902 with Otto Heintz, a talented metalworker and jewelry maker whose work also appears on these pages.

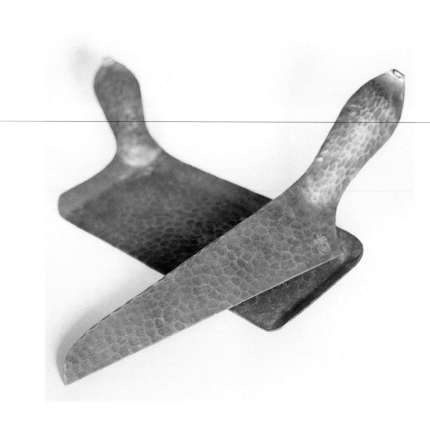

At
Home
with
Arts
and
Crafts

ROYCROFT CATERED TO every aspect of domestic life, especially since the many visitors to the Roycroft Community were eager to take an Arts and Crafts souvenir home with them. The metalwork produced by the Copper Shop, such as this table crumb tray and sweep and dish with fern pattern (circa 1910 to 1912) served both useful and decorative functions.

CARENCE CRAFTERS

HEAVILY GEOMETRICIZED FLOWERS AND INSECTS TYPICALLY ORNAMENT
the metalware of Carence Crafters, an intriguing Chicago firm about which very lit-
tle is known today. The dragonfly motif on the smallest tray (possibly for holding
stamps) is typically whimsical. Silver and brass finishes on these copper objects—
ranging from an inkwell to letter and pen trays, all dating from circa 1905—make
them particularly exquisite.

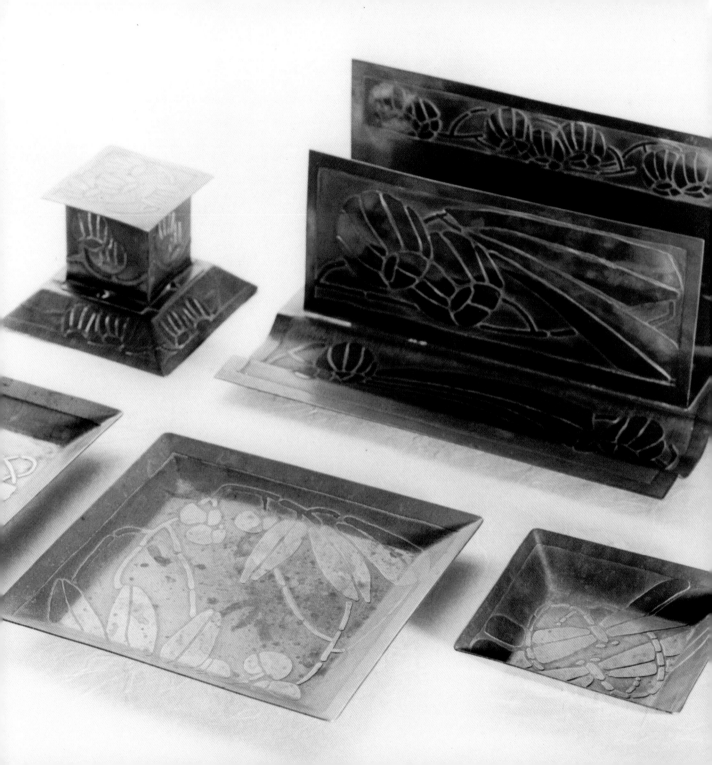

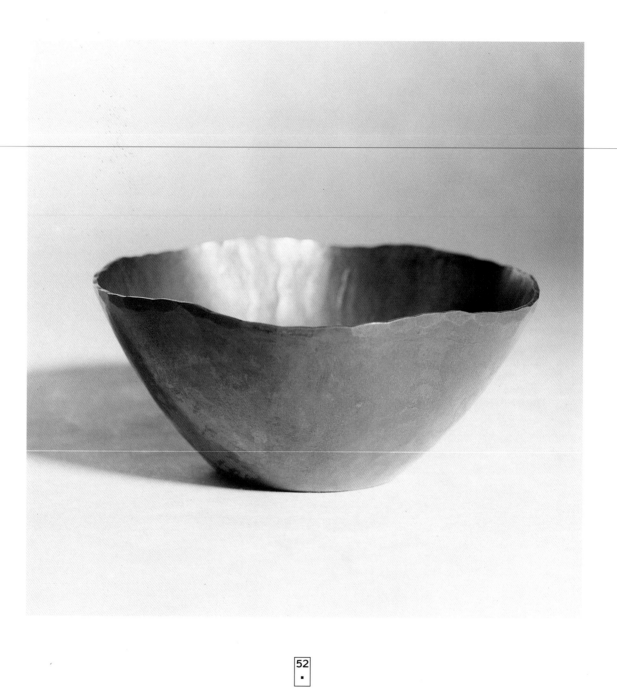

CALIFORNIA COPPER

THE ARTS AND CRAFTS MOVEMENT also coincided with a search for indigenous American subject matter. Garden flowers such as poppies, pansies, morning glories, irises, daisies, and roses were often employed as themes. The poppy—used as a theme on the circa-1915 copper candlesticks shown here by an unknown maker—certainly seems particularly appropriate to California, where it throngs fields and hillsides in the springtime. While the bowl, designed by Harry St. John Dixon sometime between 1915 and 1925, is not an exact reproduction of a poppy, its wavy, almost free-form sides and reddish color certainly convey the feeling of a blossom.

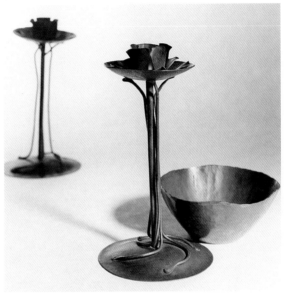

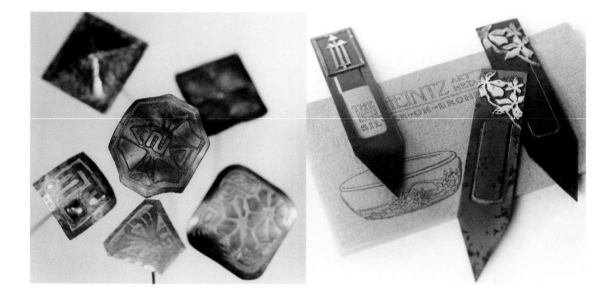

PERSONAL ACCENTS

NO ITEM WAS TOO SMALL FOR THE Roycroft Copper Shop and other makers of metalware to produce and sell. Arts and Craft hatpins, jewelry, and other small items were clearly in demand. This selection of copper and brass hatpins includes work by Roycroft, Carence Crafters, and the Forest Crafts Guild and dates from circa 1905 to 1918. It should be noted that not only were Arts and Crafts objects specifically made for women, but women were also metalworkers themselves—for example, the talented and influential Clara Barck Welles of the Kalo Shop as well as the women metalworkers of Roycroft.

Bookmarks were also popular gifts and were executed in elaborate designs of bronze with silver overlay, as are these examples by Otto Heintz of Heintz Art Metal, created circa 1912 or later. The Arts and Crafts lifestyle was a philosophical one, given to much study, and objects such as bookmarks lent themselves perfectly to thoughtful pursuits.

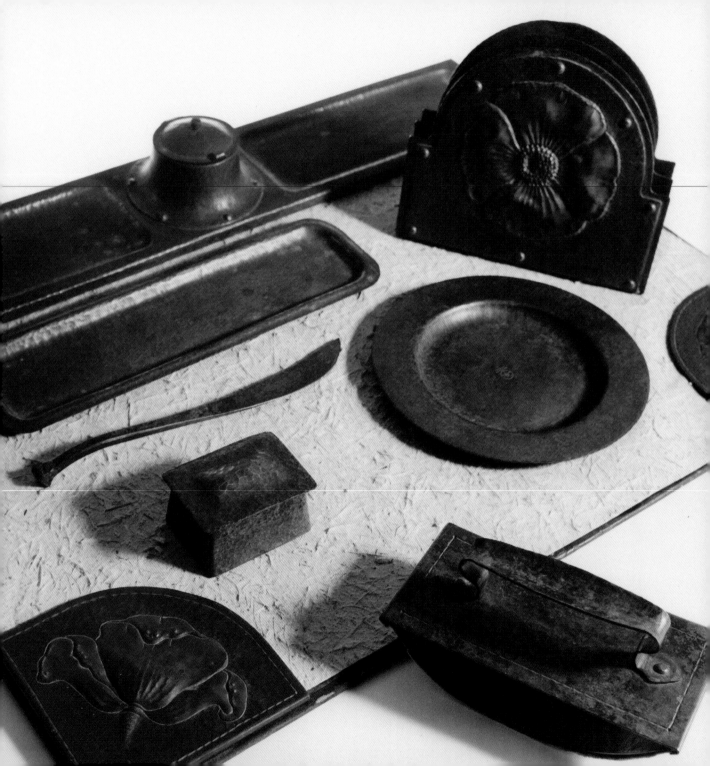

POPPY DESK SET

THE GREEN PATINA THAT DISTIN-guishes this circa-1912 copper poppy-motif desk set is extremely rare, although Roycroft products adorned with poppies are relatively common. The subtle patina was probably produced with chemicals to achieve this look. Desk sets were one of the most popular items made at Roycroft, back in the days when every polite gentleman owned and used a properly set-up desk for both business and personal correspondence.

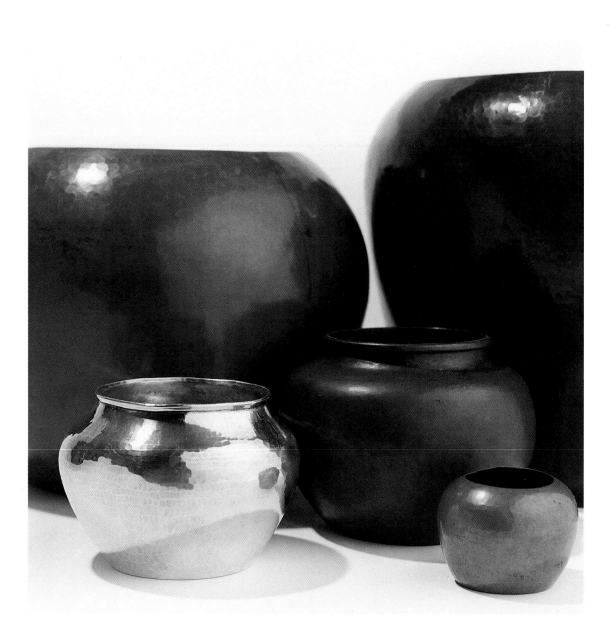

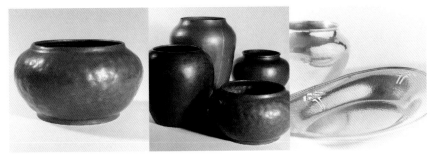

RED WARTY WARE

DIRK VAN ERP IS KNOWN FOR the individuality of his expression. Perhaps the most distinctive of the many pieces that originated in his shop are those known as "red warty" ware, which have a distinctive knobby, irregular surface and a surprisingly bright red-orange color. Creation of the bumpy surface was a long, tedious process requiring the utmost in metalworking skill. These pieces, robust but refined, have an appealing earthiness. The red patina, sometimes called "fire color," is variegated and streaked in myriad tones. Shown here are copper and silver-plate vases, tray, jardinieres, and a bowl created circa 1910 to 1920. The treelike cutouts on the silver-plate tray (perhaps a bread tray) are similar to motifs that appear on various other Arts and Crafts pieces; this particular one, which resembles a highly abstracted oak tree, is one that van Erp seems to have made his own (far right).

SOURCES

ARK Antiques
Box 3133
New Haven, CT 06515
203/498-8572
Specializing in silver and jewelry

Arts and Crafts Emporium
434 North La Brea Ave.
Los Angeles, CA 90036
213/935-3777

Cherry Tree Antiques
125 East Rose
Webster Groves, MO 63119
314/968-0700

Dalton's American Decorative Arts
1931 James St.
Syracuse, NY 13206
315/463-1568

Duke Gallery
312 West 4th St.
Washington Square Plaza
Royal Oak, MI 48067
313/547-5511

Philip Gabe Arts & Crafts
603 Grant St.
Iowa City, IA 52240
319/354-3377

Raymond Groll
P.O. Box 421
Station A
Flushing, NY 11358
718/463-0059
Specializing in Roycroft metalwork

JMW Gallery
144 Lincoln St.
Boston, MA 02111
617/338-9097

Kurland•Zabar
19 East 71st St. (Madison Ave.)
New York, NY 10021
212/517-8576
Specializing in 19th- and 20th-
century decorative arts

Mission Oak Shop
109 Main St.
Putnam, CT 06260
203/928-6662

David Rago Arts & Crafts
9 South Main St.
Lambertville, NJ 08530
609/397-9374

Terry Seger
3730 Moonridge
Cincinnati, OH 45248
513/574-8649
Stickley Brothers, specializing
in copper

Split Personality
223 Glenwood Ave.
Leonia, NJ 07605
201/947-1535
Specializing in English Arts and
Crafts

David and Sandra Surgan
Suite 123
328 Flatbush Ave.
Brooklyn, NY 11238
718/638-3768
Specializing in Heintz Art Metal

Twentieth Century Consortium
1911 West 45th St.
Kansas City, KS 66103
913/362-8177

Woodsbridge Antiques
P.O. Box 239
Yonkers, NY 10705
914/963-7671

AUCTION HOUSES

Christie's
502 Park Ave.
New York, NY 10022
212/546-1000

Christie's East
219 East 67th St.
New York, NY 10021
212/606-0400

Fontaine's Auction Gallery
173 S. Mountain Rd.
Pittsfield, MA 01201
413/448-8922

David Rago
American Arts & Crafts Auctions
17 S. Main St.
Lambertville, NJ 08530
609/397-9374
Specializing in the sale of Arts and
Crafts objects at auction

Savoia's Auction, Inc.
Route 23
South Cairo, NY 12482
518/622-8000

Skinner, Inc.
2 Newbury St.
Boston, MA 02116
617/236-1700

Sotheby's
1334 York Ave.
New York, NY 10021
212/606-7000

Don Treadway
2128 Madison Rd.
Cincinnati, OH 45208
513/321-6742

HOUSES TO VISIT

Craftsman Farms
2352 Rte. 10 West (Parsippany)
Box 5
Morris Plains, NJ 07950
201/540-1165

The Gamble House
4 Westmoreland Pl.
Pasadena, CA 91103
818/793-3334

Grove Park Inn
290 Macon Ave.
Asheville, NC 28804
800/438-5800

Roycroft Campus
South Grove St.
East Aurora, NY 14052
Original buildings (not all open to
the public), shops specializing in
Arts and Crafts items.

Frank Lloyd Wright Home
and Studio
951 Chicago Ave.
Oak Park, IL 60302
708/848-1976

CONFERENCES AND SHOWS

Arts and Crafts Quarterly
Symposium
c/o The Arts and Crafts Quarterly
609/397-4104
Annual conference, held at
Craftsman Farms in August;
includes seminars, exhibits,
and antiques show.

Grove Park Inn Arts & Crafts
Conference and Antiques Show
Asheville, NC
800/438-5800
Annual conference, held at Grove
Park Inn in February, includes sem-
inars, tours, and antiques show.

Annual Arts and Crafts Period
Exposition and Sale
Metropolitan Antiques Pavilion
110 West 19th St.
New York, NY 10011
212/463-0200
Held in May

For information on a variety of
antiques shows in the Northeast,
focusing on the twentieth century,
contact:
Sanford L. Smith & Associates
68 East 7th St.
New York, NY 10003
212/777-5218

PUBLICATIONS

The American Bungalow
123 S. Baldwin, P.O. Box 756
Sierra Madre, CA 91025
800/350-3363
6 issues/year

Antiques & Fine Arts
255 N. Market St. Suite 120
San Jose, CA 95110
6 issues/year

The Craftsman Homeowner Club
Newsletter
31 S. Grove St.
East Aurora, NY 14052
3 issues/year (part of club
membership)
716/655-0562

The Arts & Crafts Quarterly
9 S. Main St.
Lambertville, N.J. 08530
4 issues/year

The Grove Park Inn Show Catalog
Available through Bruce Johnson,
P.O. Box 8773,
Asheville, NC 28814
Contains valuable information on
aspects of Arts & Crafts collecting.

CONTENTS: Copper vase; Roycroft; variation on American Beauty form, c. 1912-15; Raymond Groll.

P. 9: Copper and silver vases, bowls, and trays; Dirk van Erp, c. 1910-20; Raymond Groll.

CREDITS

PP. 12-13: Copper American Beauty vases; Roycroft, c. 1912; Woodsbridge Antiques.

PP. 14-15: Pewter vase, cream jug, and sugar bowl; after designs by Archibald Knox, Liberty Tudric, c. 1903; private collection.

PP. 16-17: Copper tray and cedar-lined cigar box; Gustav Stickley, Craftsman Workshops, c. 1908-16; Raymond Groll.

P. 19: Brass vases, made from surplus shell casings; Dirk van Erp, c. 1904-1908; scallop-top: Arts and Crafts Emporium of Los Angeles; flat-top, private collection.

P. 20: Copper ashtrays, candleholders, and trays; Roycroft, c. 1908-10; Raymond Groll.

P. 23: Bronze vases in green and brown patinas with sterling silver overlay; Otto Heintz, Heintz Art Metal, c. 1912-28; David and Sandra Surgan.

P. 25: Copper Italian polychrome vases and bowls; Roycroft, c. 1912; Raymond and Helen Groll.

PP. 26-27: Left to right: Copper cigarette box with horn ornament; Albert Berry, c. 1925; private collection. Copper box with enameled lid; Handicraft Society of Boston, c. 1910-16; private collection. Enameled copper box; Art Crafts Shop, c. 1905; Stephen Gray. Pewter cigarette box; Harry Dixon, c. 1920-25; Kurland-Zabar. Copper stamp box; Gustav Stickley, Craftsman Workshops, c. 1910; Dalton's Decorative Arts. Copper box with enameled lid; F. C. Varley, Guild of Handicraft, 1905; Kurland-Zabar. Copper box; John Pearson, c. 1900; Kurland-Zabar. Enameled copper box; Art Crafts Shop, c. 1903; Stephen Gray. Bronze and silver box; Heintz Art Metal, c. 1906; Raymond Groll.

P. 28-29: Copper bowls and vase; Harry St. John Dixon, c. 1915-25; Raymond Groll.

P. 30: Pewter claret jug with green glass body and glass fruit bowl in pewter stand; after designs by Archibald Knox, Liberty, c. 1903; Kurland-Zabar.

PP. 32-33: Pair of pewter biscuit boxes, one with enamel cabochons; after designs by Archibald Knox, Liberty, c. 1903; Kurland-Zabar.

P. 34: Bronze Theta and Iota candlesticks; Robert Jarvie, c. 1904-1910; Stephen Gray.

P. 36: Silver bowl; Artificers' Guild, Edward Spencer, 1912. Kurland-Zabar.

P. 37: Silver cloak clasp; C. R. Ashbee, Guild of Handicraft, c. 1904. Kurland-Zabar.

P. 39: Copper bookends (top group of three, left to right): Ship motifs; unknown maker, c. 1915; private collection. Dirk van Erp, c. 1910-15; Arts and Crafts Emporium of Los Angeles. Copper bookends (bottom group of five): Albert Berry, c. 1920-30 (top row, left). Walter Jennings, prototype for Roycroft, c. 1912-15 (top row, middle). Albert Berry, c. 1920-30 (top row, right). Attributed to Walter Jennings, Roycroft, c. 1912-1915 (bottom row, left). Karl Kipp, Tookay Shop, c. 1912-1915 (bottom row, right). All from Raymond Groll.

P. 40: Pewter bud vase and tea tray; after designs by Archibald Knox, Liberty Tudric; tray, c. 1901, vase c. 1903-04; Helen Groll.

P. 43: Copper candlesticks and tobacco jar; Karl Kipp, Roycroft, c. 1910-12; Raymond Groll.

P. 44: Top left photo and (detail) bottom right photo: Water pitcher; Lebolt, c. 1918. Coffeepot; Randahl Shop, c. 1916. Coffeepot (from set); Lebolt, c. 1925. Pitcher; Kalo Shop, c. 1911. Water pitcher; Randahl Shop, c. 1926. Milk pitcher; Robert Jarvie, c. 1913. Top right photo: Child's cereal bowl with tray; Kalo Shop, c. 1910. Condiment serving piece; Lebolt, c. 1916. Bottom left photo: Martini spoon; Lebolt, c. 1920. Bonbon spoon; Lebolt, c. 1915. Serving spoons; Kalo Shop, c. 1920. Fish server; Kalo Shop, c. 1925. Tea strainer; Randahl Shop, c. 1917. Pair of serving spoons; Fallick Novick, c. 1925. Brandy spoon; Randahl Shop, c. 1925. Cheese scoop; Lebolt, c. 1920. All from ARK Antiques.

PP. 46-47: Copper and brass boxes with enamel; Art Crafts Shop, c. 1900-08; Michael and Janine Garey (inkwell); Raymond Groll (all others).

PP. 48-49: Copper table crumb tray and sweep; Roycroft, c. 1910-12. Copper fern dish; Roycroft, c. 1910-12; Raymond Groll.

PP. 50-51: Copper letter tray, pen tray, inkwell, with silver and brass finish; Carence Crafters, c. 1905(?); private collection.

P. 52: Copper bowl with red patina; Harry St. John Dixon, c. 1915-25; Mission Oak Shop.

P. 53: Copper poppy-motif candlesticks; maker unknown, probably California, c. 1915; private collection.

P. 54: Copper and brass hatpins; Roycroft, Carence Crafters, Forest Craft Guild, c. 1905-1918; Helen Groll. Bronze bookmarks with silver overlay; Otto Heintz, Heintz Art Metal, c. 1912 or later; David and Sandra Surgan.

P. 56: Copper desk set with unusual green patina; Roycroft, c. 1912; Raymond Groll.

PP. 58-59: Copper and silver-plate bowl, vases, tray, and jardinieres; Dirk van Erp, c. 1910-20; Raymond Groll.

INDEX